From the shores of Australia Wisconsin, Talbot's poems st "joyful absurdity." Here we m the devil, a maestro, a math......—caught in endearing moments of silliness or grandeur. Talbot captures the ephemeral feelings of connectedness we all have but seldom manage to put into words. The natural world, too, comes alive under the watchful eye of this poet—in spontaneous rhythms that honor her musical heritage. So, sit back with a cocktail (or a bold latte), and let Talbot's verse bring "a peachfire of/ ripeness in each hand/ to your darkness."

—DAVID SOUTHWARD
senior lecturer at Honors College,
University of Wisconsin-Milwaukee

Katrin Talbot's *The Devil Orders a Latte* is a tour-de-force delight. Her poems are witty in all the right places. They're musical in subject and language. No surprise! She's a talented musician. Her imagery is deeply observant. She's also a photographer. "She wanted us to infuse the landscape with music." In these poems, readers will meet Madame Nannette, who designed pianos in the early 1800s, a female rabbi getting a manicure, and the devil, of course. "Last night/ I shoveled the stars off/ the walks/ and threw them into the galaxy/ ...." Simply lovely!

—KARLA HUSTON
Wisconsin Poet Laureate 2017–2018,
author of *Ripple, Scar, and Story*

"... we all have our voices,/ raise them in the saying vein" charges poet Katrin Talbot in her collection, *The Devil Orders a Latte*, with poems rich in seeing but also feeling—one might say taut, her lines swift and spare down the page. If you've ever wondered if there's music in everything, Talbot answers with a resounding *YES!*: the music of the concert hall, the music of the creatures beyond the window pane, the music of your own beating heart. She finds music in the appearance of a white deer on a far hill, "the quarter-of-a-century / dance of a gene," and the world around us, "a landscape of trill and swing." These musics and rhythms are interior and exterior, of the human world and exceeding it. Her voice telescopes in and out of experience, capturing moments large and small. The close focus on making music together is particularly fine: "a joy from friction—the/ sap on the horsehair/ grabbing the silver and/ pulling exultation out of wood."

—C. Kubasta
author of *Abjectification* and *Of Covenants*

# The Devil Orders A Latte

Katrin Talbot

Fernwood
PRESS

# The Devil Orders a Latte

©2024 by Katrin Talbot

Fernwood Press
Newberg, Oregon
www.fernwoodpress.com

All rights reserved. No part may be reproduced
for any commercial purpose by any method without
permission in writing from the copyright holder.

Printed in the United States of America

Cover and page design: Mareesa Fawver Moss
Cover image: Adelina Dumitrescu
Author photo: Isabel Karp

ISBN 978-1-59498-147-0

*This is dedicated to my chickens who don't give a cluck about poetry unless it has mealworms in it*

# Contents

Introduction ................................................................. 13
I. The Rabbi Gets Her Nails Done ........................... 15
   I Play My Scales to the Mourning Doves ............... 16
   Blessing in a White Dot ............................................ 17
   The Piano Tuner's Beat ............................................ 18
   Shadow Sword ........................................................... 19
   The Rabbi Gets Her Nails Done ............................ 20
   Hot Stars ..................................................................... 21
   The Old Mathematician
      Dials His Cell Phone ......................................... 22
   Passported ................................................................. 23
   Madam Nanette ........................................................ 24
   Beneath ...................................................................... 26
   Puddle ........................................................................ 27
   Counting Bars .......................................................... 28
   Here We Go Round ................................................. 29
   Allocation .................................................................. 30
   Pull me through your Hallelujahs ......................... 31
II. The Devil Orders A Latte ..................................... 33
   New Repertoire ........................................................ 34

The Night I Played a
    Beethoven Sonata Drunk ............................................. 35
Maestro ........................................................................... 36
Named ............................................................................ 37
The Devil Orders a Latte .............................................. 38
The City Was Heavy with
    Beethoven Last Night ................................................ 39
Two Sixteenths, Two Eighths ..................................... 40
Diva Lite ......................................................................... 41
Galileo After the Trial .................................................. 42
A Motorcycle Drove
    Right Through Prokofiev ........................................... 43
Horizon .......................................................................... 44
World Without End ..................................................... 45
III. Backstaged ............................................................... 47
    The Premiere of a Sixth Quartet ............................... 48
    Mrs. Morpurgo ........................................................... 50
    Fanfare .......................................................................... 51
    Return from the Land of Injured ............................. 52
    Sir John A. McDonald ............................................... 53
    I live among the crows .............................................. 54
    *In* the language ........................................................... 55
    Twenty Hearts ............................................................. 56
    Reverse .......................................................................... 57
    The Shopping Cart Estates ....................................... 58
    *In* the dream after ....................................................... 59
    The Barber of Seville Stirs My Coffee ..................... 60
    In Which a Chorus of Crow ..................................... 61
IV. Backlit ....................................................................... 63
    March Fourth .............................................................. 64
    In the Key of Donut ................................................... 65

| | |
|---|---|
| *It's* not the glacier's imperative | 66 |
| Supermarket Morality | 67 |
| Invitation to the Polka | 68 |
| A Few Words | 69 |
| In Which the Milwaukee Symphony Forgets to Pay the Violas | 70 |
| It Is with Great Honor | 71 |
| Night Snow | 72 |
| Drive | 73 |
| Why I Keep | 75 |
| Build Me a Bridge of Bones | 76 |
| Angus | 78 |
| The Twigs | 79 |
| Ballet Arithmetic | 80 |
| A Trio of Crow | 81 |
| Contours | 82 |
| Acknowledgments | 85 |
| Title Index | 87 |
| First Line Index | 91 |

*Faust* And what must I give in return?

*Méphistophélès* Practically nothing.

# Introduction

Every birthday party of mine had two cakes. Being a twin gave me a constant second take on life, and this collection reflects these experiences. They're there, leaning into each other, trying to balance outlooks and sometimes falling with a resounding crash but vital and resilient, just like sibling love. *The Devil Orders a Latte* emerged after Mephistopheles had just sung his way through an aria and now was ordering a latte in front of Faust, Marguerite, and me at the café where we were all fueling up at break from opera rehearsal. These poems are not about deception of the curtain nor the mask but about the several worlds we can spin through and their fundamental incorporeity and joyful absurdity.

—Katrin Talbot

# I.

# THE RABBI GETS HER NAILS DONE

## I Play My Scales to the Mourning Doves

Because they're stuck
with just a few tones
with a glissando or two
I want to feed them
more notes in
this hungry late spring
train their inner diva
expand their repertoire

But I stop
And listen to their call back
And stay for the rest of the morning
between a few
perfect
notes

# Blessing in a White Dot

Handed to me
by the local who rolled by
rolled down his pickup window
as I stood in early evening alfalfa
with camera and adjacent art
installation

*See that white dot up the hill?*
*White deer.*

I might see more on
the other side of the hill
along there, then right

A quarter-of-a-century
dance of a gene
hanging out
generation after generation
in the glaciated lands,
this ghost angel animal
carrying the mutation
such that this deer
could stand in an emerald field
and with an
exquisite absence,
sing

# The Piano Tuner's Beat

It's not anything
like the pulse
of a body asleep
Bigger
Loopier
the way it
goes between a solo note,
an interval
the hammering
the tightening
repetitive and unpredictable
—the way you are
in my heart—
until it becomes
the pianist's heartbeat
the ragtime bass
Chopin's imperative,
Scarlatti's
folly

# Shadow Sword

A drive to a morning lake swim
and the car in front of me
has been cutting down each
hazard cone for miles now
with a shadow of Chevy

The way grief can
silently slice through
hazard zones for leagues,
the drive home,
softer

# The Rabbi Gets Her Nails Done

She sat in front of me
and my eyes
traveled along her unfettered hair,
the gray waves rippling
down her back,
the no-nonsense specs
presiding over the
Old Country nose

Yet when I noticed her perfect manicure
I was forced to pry my mind
open even wider
as I wondered what a rabbi
and manicurist would
chat about, share—
if the rabbi could confide
finally outside her receiving realm
but mostly, would it be
nerve-wracking or liberating
to paint such
wisdom?

## Hot Stars

*Oh Be A Fine Girl, Kiss Me*

You spent all those nights
in the Harvard Observatory
with your brilliance
and that of the stars
and, Annie Jump Cannon,
you lived a destiny bestowed
by a naming, an implied duo
trajectory
off the earth.
And so
maybe you didn't give
those kisses,
maybe you did
but we can thank you
over a century later
for your mnemonic *o b a f g k m*
the stars more comfortable now
with your temperature-dependent
classification
in their own
sultry
skins

*Annie Jump Cannon, 1863-1941, classified 230,000 stellar bodies and discovered 300 new stars. She was paid 25¢ a day.*

# The Old Mathematician Dials His Cell Phone

It's not that he can't
see the numbers—
we all, at this age and that,
have weapons of defense
against the blurring

It's the way he dials
checking each finger's work
announcing each number
with the solemnity of a
respectful butler
then pausing after the
summation to pay homage to
the combining,
to ponder the potential
of number association
before he presses the
lettered call button
and listens to the rhythm
of a lilting song
of ten

*for Robert McKelvey*

# Passported

I was always on my
American mother's passport
a hen and her tawny
Australian chicks
captured for a brief moment
when they weren't running
along the sands looking
for shark teeth or climbing
a loquat tree to lunch

My passport to clamber onto
those spaceship boats to sail across
the planet or fly in those
silver time capsules, held not by
a mother's arms
but by the fascinating inventions of
minds that clicked

A citizen, now
in the world of
motherlands

# Madam Nanette

In the etching, she is a strong face
sharp eyes, mobcap

I'm in love
Except for the mobcap

Played for Mozart at eight—
already enough in the dazzle department—
but by ten, she carried the genius label over to
piano building in her
father's workshop

At twenty-three, she rafted the pianos on Danube's waves
to Vienna, hired her husband as
bookkeeper and head of sales

Vienna, the new place of business
closer to Beethoven, her dear friend,
building bigger and louder.
The large new concert halls and Ludwig demanded it
Five octaves now six and a half

She lost a six-year-old son
That's part of what is seen in those etched eyes
All of this, and scholars switched the roles
of Nanette's and husband
like a child's chess game
like equine side-blinders for
trotting in a straight line
along the tidy boulevard of gender history:

He, the builder, manufacturer
She, helper

How *could* a girl master
the building of pianos in 1779?

She did a grand job in the genetics department,
her grandson building pianos for Brahms

Mozart, Beethoven, Brahms

A nice string of pearls
on a strong neck

# Beneath

This afternoon
my spade scraped
against a few rocks
below the garden's
verdant skin,
unearthing a toy soldier
and a legless footballer

What we keep buried
for decades
unscraped truths
granite resentments
and a few forgotten
wars

# Puddle

This morning
it's just an innocent footprint
of the thunderstorms that
cracked open sleep all through
the flashing hours:

a bit of water carrying the world
if you walk around it,
the calm, spent sky
the tree's stilled hallelujahs
the clothesline and other earthbound
detailing of the backyard

and if you lean in and over,
your shoulders, beautiful beneath
the pale moon of a sun
holding up a heaven's rippling
with a simple shrug

# Counting Bars

We really do not need to
at this point; we know
the path through the woods
the dreaming, the plot
twists

But just in case,
our fingers mark
the passages
until we all lift
our instruments
in unison, in relief for
an accurate count
ready for
the upcoming
polyphony,
the imminent
wonder

## Here We Go Round

I think of the rhyme as
my garden clippers shear
the wayward branches
their suggestion of fig leaves

The story of the mulberry sprig from a
nearby country club's tree planted in
an English prison yard, which grew into
a circumference big enough for
moonlight exercise with female prisoners
and their song of memories

And the story of wanna-be silk magnates
in cold and frosty England

So here I go with rhyme and blade
*This is the way*
*the ladies walk*

# Allocation

We share a street, some unhoused and I
Well, they are only temporarily
not unhoused

and I just park there
when I go into my evening world
of late Beethoven string quartets
and lieder recitals

and when I stagger back
from the concerts drunk with the
complexities of themes and
modulations

they're still there on the porch
benched with their own minor keys
and their very own complexities
not someone else's to contemplate

so maybe we share the song of the street
the wayfarer, for a moment
when nothing is said between us
or maybe not

but I know what I see every time
on every face—the emotional crust
the street life bestows

the patina of loss
on their vivid,
guarded faces

# Pull me through your Hallelujahs

past the ghostly
antebellum

under the blue,
over the blues

across a landscape of
trill and swing

into the offbeats
pulling and driving

Show me a history
a rising, a victory

sing it in a dazzle
woven with question

ride a high road,
answer in the augmented key

of
joy

*inspired by William Grant Still's
Symphony No. 1 "Afro-American"*

# II.
# The Devil Orders A Latte

## New Repertoire

I locked the clever talking heads
in the car as they
spun out their dazzling knowledge
on a Met broadcast intermission

Enough of *Lucia di Lammermoor*
and her madness
her high notes!

I wanted the clever snowy prairie
laced with dazzling frozen woods
the madness of sun in winter
the high notes in the pines

And when I returned from
the stroll
there they were, a quartet,
not soprano, nor mezzo, tenor, bass
but four wild turkeys on the blacktop
foraging for a nicely salted
lunch at the edge of the icy parking lot

and as I moved toward them
they moved with me
their stick feet clicking their
slow alert path of retreat
along the pavement
composing a soft percussive quartet
of the wildest
proportions

# The Night I Played a Beethoven Sonata Drunk

Well, so was the
pianist

We were just reading,
screaming with delight
at the missed high notes
the unexpected chord progressions

A forgettable reading
musically
An unforgettable one
dramatically

Act III of Living,
Living Well, Loudly
Happily

before the Rest of It
moves in
in Act IV

*for Terry Bonney*

## Maestro

He said
here, sink down
here, lighter, sing to yourself
begged, he did, there
for air in these notes
and here
reach down and
pull the richness up into
the line,
play, of course
in the dark chocolate mode
and for this chord, swell
like blowing gently on an
ember
capture the momentary flare
bass line first and last
as he threaded his baton
with phrases pulled out of us
like soft taffy
and we played Brahms Three
for the very first fifteenth
time

*for Maestro Carl St. Clair*

# Named

In town
he's known by his brain's wiring

You pick him up—he doesn't drive—
unite him with your piano
Leave him
Don't ask him too many questions
Allergic to small talk—
shuts him down like a heavy lever
like a thunder cloud, seeks cover

At the keyboard he is, at first, a child;
knuckled clusters of piano keys between
intervals of silence
Later, he lies down with his boots
on, takes, in our assumption, a nap

While his *absorption in self-centered
subjective mental activity*
monopolizes the front row,
the intervals are processed
as the raucous light behind his lids
rearranges the diffraction's map
He awakes and begins the afternoon
of adjustments and when his work is done
the piano shimmers within
a pluperfected
tonal galaxy

# The Devil Orders a Latte

and a piece of crumb cake
Charms the barista

Faust is indecisive and
holds up the line
trying to decide
what will serve his
needs best

Valentin's order is
forgotten, as usual

And Marguerite doesn't
think twice about ordering
that triple chocolate brownie
and adding whipped cream
to her cappuccino
because, in the end
she knows she can
get away with
murder

# The City Was Heavy with Beethoven Last Night

as we streamed out from
the concert hall
back to
other fragments of
our lives
all carrying
a phrase
an emotion
a recognition
home through
the darkness
of a sad brilliant rain

And this morning
it has soaked in,
that which
we embezzled last night,
that which
has released a few more
necessary molecules
of clarity
into the complicated
metabolism of
soul

# Two Sixteenths, Two Eighths

It's a simple pattern
beautiful, in fact, as
it lays silently on the staff
two sixteenths followed
by two eighth notes,
holding hands

And in this moment
I sing through my fingers
*Hallelujah*
A joy from friction—the
sap on the horsehair
grabbing the silver and
pulling exultation out of wood
to land wherever extolling
is a virtue, in the realm of
the god of just breathing,
whatever inside you
merits Olympic gold
trumpets and a fermata
that just might
never ever end

# Diva Lite

Plays nicely
with others

Doesn't require
a gilded carriage
from which they
might call their agent
to order them
to call the chauffeur
and demand that he
turn down the AC

Knows their place in the
World of Ears
that they might don a crown
claim the small kingdom
wear a little more bling
but don't, due to the fact
that they can still feel the earth
beneath their fancier feet
hear the brighter crystal voices
outside the window
in the branches'
stunning chorus

*for William Lutes*

# Galileo After the Trial

He passed me like a caffeinated ghost in
the hall, his robes brushing against my legs

as I sat on a backstage table after scene
four, resting my limbs and eyes

between minimalism's maximum
challenges to fingers and brain

"You guys sound great!" he said in un-Italian
as he flowed by

He was texting, or I was—I can't remember
but the absurdity shimmers still in

my memory, just before the fifth scene in which
he would pen the *Dialogue Concerning the Two*

*Chief Systems of the World*, the one that got him in
deep doodoo with the Pope back in scene two within

the reverse temporal structure of the opera.
I swung my pendulum fishnet legs through the

final minute before the call for tuning
in collegial defense of the

Copernicus theory

*—during performances of Galileo Galilei,*
*an opera by Philip Glass,*
*with the Madison Opera*

# A Motorcycle Drove Right Through Prokofiev

's flute sonata
a ripping around-the-curve
crescendo-decrescendo

Much less damage sustained than
the thrush under the eaves
competing
with the flute's spiky passages

We all have our voices
raise them in the saying vein,
often an indigo echo
of response
sometimes oblivious to
what shall witness the call
the unexpected fusion
the unfathomable mélange
of truth and other nonsense,
the roar before a sonata form's
elegant reprise

*for Stephanie Jutt and Jeffrey Sykes*

# Horizon

She wanted us
to infuse the music
with landscape
*Horizon!* she'd plead throughout the
Tchaikovsky, Sibelius
She described her northern Finnish
coasts unfit to live on
the constant brutal winds which
she wanted at measure 172
but I was offstage already, up
on that jagged coast, a scrubby pine
rooted
in windswept rock
with D minor chords roaring through
my branches, shards of
prevailing magnitude, velocity
whipping through,
needled knots etched
into my limbs
My only charge to cling
resist, endure, embrace
to ground myself in the living
part of a tempestuous life

*Maestra Anu Tali*

# World Without End

> A new translation from the Latin text
> by a local field mouse

I'm guessing it was a night
last week
during those rehearsals of
Rossini's *Stabat Mater*
that the owl
dined so well
judging from the scat secrets
I found in the prairie

Upon a closer reading
*Mother of Sorrows*
a delicate signature
emerged
a procession of
tiny white bones
authenticating
the
inevitable

*in sempiterna*
*secula*

# III.
# BACKSTAGED

# The Premiere of a Sixth Quartet

He doesn't seem nervous.
He's done his work
knows they have—
the calluses tell the story—
*another time*, the title
another premiere,
the composer who
is seated next to me.
He moves with the phrasing through
the first movement, then the
score settles back into his head—
I can hear it buzzing if
I lean in close enough

Is he listening to the music
the audience, the ensemble
of perception?
He checks the piece's progress
like the rest of us with glances
down at the program—
the lines chase each other, catch
up, vary as variations must,
weave and build toward and
away from the source
crystallizing into brilliant finishes

and the witnesses embrace it
with a hand, knowing it's a
privilege in the tradition of
stage births
and the shimmer of *premiere*
fades in a lovely way as it
slips
down the last slope of its
gentle bell curve

*for Joel Hoffman,
at the Pro Arte Quartet premiere*

# Mrs. Morpurgo

> And her voice is a string of colored
> beads
> or steps leading into the sea
> —Edna St. Vincent Millay

A blessing for Australians
to move next door to Italians
in a bitter northern climate

A Mediterranean smile
dark and sparkling eyes
much more warming than itchy wool
in a deep foreign winter

And summer, when
the skin betrayed itself
to stinging hordes of insects,
my new life behind the screens
was threaded with
the shimmer of her voice
as her arias spilled down
the back steps like a broken strand
of Venetian beads
opened and released
into my breathless, waiting
new world

## Fanfare

It was her second egg of
the return to laying;
a long winter had kept
them as sealed secrets

Enough light had been the cue
as the girls had ventured
out of the coop this last week
to harvest the air, the sunshine
and, as I heard her settle herself
in the nesting
I chose to sit out in the crisp
sunshine, so bright in
the snow's presentation
and wait for her
post-egg declaration, a fanfare in
the key of egg,
announcing the laying of
another perfect
non-heptagon

# Return from the Land of Injured

The cello,
enforced hibernation,
squints at the light as
strings are tuned
And now, the adjudicated exam
as each finger reacquaints itself
with the silver, the ebony

The tender, uncalloused
fingertips
entering the playground as
the new kid
quietly swinging alone
tentative, then
with the muzzled determination
of a warlord
a racehorse at the gate
a lover waiting for
the train to arrive
at last

*for Parry Karp*

# Sir John A. McDonald

Oversaw, from his letters
fastened to the school's entrance,
critical lessons in my Canadian
life for three years:

The insecurity behind brutal teasing as
our thick Australian accents
retreated in only three months
lives splintered behind bullying

But, best, within his named school
how a shiny violin felt
in my little hand
my playing now
a successful technique to scatter
horrified cats
my violin case now an
imaginary weapon, if needed,
to fend off
bullies

*I live among the crows*
so when I visit the ravens
I find, every time
I melt down to my core,
just an elemental shudder
And when I see the soaring black
I reconstruct my molecules
to receive the guttural goiter dialect
the metallic scrape through
my inner tender
the cry to strengthen the ligaments
begin the stitching of the bones,
mine, and not those in the dark bird's
nestmass of discards, wool, bone, stick
and when the grating black ravenelle
is finished for the moment
I remember to breathe and watch the sun
moved toward another black
woven with scouring chants
and my night thoughts are
floating slices of darkness

*In* the language,
the dialect
of January weather
there are more than
the average numbers
of declaratives
especially, for example
this coming Thursday
with a snowflake icon
next to the high 50F
then the sun and
-2 on Saturday

It's a conversation of
exclamation, followed by
resignation, life in the state
of the state of
Wisconsin

where wearing layers is
rule number one
where, during season relay handoffs
keeping instruments in
tune is right next to
impossible

# Twenty Hearts

And I was to judge—
along with two others—
how they beat
how they sing
Eighteen concerti with
a couple of
Airs in the Roma style thrown in

But they all seemed to have
a *Roma* core
signing up to show us
their high school auras
wandering around
the fingerboard
flashing their
astonishing bows
stealing our
adjudicating hearts
one octave at a time

# Reverse

After the final chords
the applause's shimmer
the orchestra no longer a word
just a concept now
unraveling into people with
instruments
to put to bed
as the brass slowly
debrief their lips,
as the percussion
begins the mastermind
strike of setup,
as the strings put their instruments
to bed, cleaned of rosin
bowhair loosened
release of duty 'til
the next open case

# The Shopping Cart Estates

We went to the park around
the corner from the academy
to lose ourselves in the mysteries
of the Banyan trees
and there they were—
the deep mysteries of society
the no-income versions
of white picket fences
the quilts, the threadbare yards
beneath the loaded shopping carts
The boys under the biggest Banyan
keeping afloat beneath the roots
by a sweet morning drug deal

And on the busy street corner of the park
beneath the extravagant tree canopy
she swept and swept her cardboard floors—
empty shoes holding down
the corrugated claim,
her shopping cart containing
the possibility
of a life, her closet, her kitchen

We walked back to
the dress rehearsal
leaving the transient lives
to float beneath the comfort of the
ancient trees, and the stunning
absurdity of their
desperate
roots

*In* the dream after
a fine dinner
my fingers are asparagus
ephemeral white, northern European
Festivals celebrate my ghostly digits
and I am crowned
the Spargel princess

In the morning
before coffee
the pre-dream vegetable
lying in its elegant
china coffin, in a sauce that
suggested Russia,
turns out to be the perfect
fingering for a tricky
Rachmaninoff étude
as verdant spears direct
my day

# The Barber of Seville Stirs My Coffee

A week after opening night
my shoulders have recovered
but the operatic ghosts still
follow me around the house
with their various themes, arias

At the door, I unlock my expectations
with Doctor Bartolo's keys,
Rosina sugars my coffee
with that liquid gold aria of hers
while my spoon
catches Figaro's octaves in
its carousel ride
around and around
the standard way
art envelops the days of
in between

# In Which a Chorus of Crow

blasts into the recital
inside my head
and becomes my echo
my greasy greek chorus

You in your black rainbow robes
holding court in the old oak throne room
plotting overthrows
cutting up the backyard skies
peppering the limbs with
your ebony bodies
your inky intrigues

And then, without farewell
the taken raucous flight toward
the next gaining grove

# IV.
# Backlit

# March Fourth

*And meet the enemy*
which is what, on that day of the year
I always wrote in my
grade school papers—
a day of strength
of overcoming
of overall tenacity
the likes of which
I had no idea
I'd ever have to cling to
with such ferocity

# In the Key of Donut

Have you ever tasted a donut in
a minor key?
Heard a solo cello
sing an elegy for a
sister's fritter?
A glazed requiem?

The display case with its rows of
tiny little hallelujahs
the smiling clerk's C Major
*What would you like?*

And we all walk out,
our white bags or boxes
carrying non-liturgical
cream-filled doxologies for
our little lives of
powder'd sugar'd
praise

*It's* not the glacier's imperative,
this bubbling
this flow

It's more a question of
ebb, of moving
through, of thought drift

And the glimpse of sky water
surface shimmer
watercolor of
leaf and cloud

So, within this wat'ry progress
eddy me for an hour or two—
Let me spin without purpose in
dapple and reflection

Then loose me,
lose me into
earth's infinitesimal
angle, the float
down
stream

> *Beethoven's Scene by the Brook,*
> *Sixth Symphony*

# Supermarket Morality

You've hunted and gathered,
the mammoth's downed,
the roots and berries found
You line up to give up clams
and you slowly passed through
the Morality Security Checkpoint

Do you defy your dentist and
choose a tin of sweets from
the display calling out to your wants
to balance the brussels sprouts
Or do you turn your head
toward the tabloids and
have epiphanies about
fashion, relationships?

Do you dream of a checkout line
where packets of washed grapes
garden-fresh pea pods
sections of clementines
call to your me-me-me
Where the magazine racks
are filled with
glossy art rags
slender poetry journals
and the only celebrity relationship
you have to ponder
is a lovely nubile lass
wrapped around her
famous totally hot
Strad

# Invitation to the Polka

Back then
I was a strapping young woman
brought up on
the milk of women's lib
wheat germ
poured over my cereal
every damn morning

New to the Midwest
I joined the University's Hoofers
Outdoor Whatever Whenever Club
camped, kayaked, canoed my way
into a healthy-enough social life

So when Mister Rugged Good-Lookin'
encouraged me to sign up for
an excursion to Something Northwoodsy
Steak House/Bowling Alley, I
went along, never realizing that
after all of this and all of that
Polka-ing required the Man
to lead, until it was too late for
his tender foot

# A Few Words

About the primaries,
eagles,
soaring
taking and giving
the sky's rights to
give and take

## In Which the Milwaukee Symphony Forgets to Pay the Violas

The entire section
tight on groceries for
a week
Until, one by one
they politely inquire
and the mistake is corrected

Another viola joke
for the archives

*for Davis Perez*

## It Is with Great Honor

that I sit here and watch
the beginning of
a snowfall
the reverse of
Picasso sketching
the return to a
blank canvas
And, after a pure
whiteness has established itself
the questions arise about
Pablo and snow and canvas

But now the earth is ready
for the bunny hop artists
and the chickens' pterodactyl
tracking on this
lovely winter morning

# Night Snow

Last night
I shoveled the stars off
the walks
and threw them into the galaxy
that was formerly my
lawn

# Drive

Late afternoon highway
light leaning like a dancer's stretch
backlit after-hours bridge construction
dinosaur machines frozen in action poses

And I follow the leopard's eye taillights for miles
ponder the resilience of a quarry's taut skin
and witness the tight anger of
road rage ahead of me,
how the irrational and vindictive trumps all
when anger grabs the steering wheel

As the light wanes and the GPS switches from
day to night, I fly by so much water unseen
and then, farther north, imagine the bears
whose ambling is a blazoned diamond warning
deep in hibernation in this bizarre winter where
fall and spring keep showing up on the wrong days

And as I pass signs for the highways of
*Red Arrow* and *Blue Star*, I can barely keep from turning
from seeking a quiver or indigo twinkle,
but end up staying the course
as I listen to the young Welsh bard sing through
my dimly lit progress

*how*
   *far*     r
     r
*are we*
*fal*
  *al*
    *al*
       l
    *ing*
         g?

And my mind spins with the tires' rotations
toward a northern point
where a daughter awaits
my arrival in this deep winter's
trip of
trips

# Why I Keep

singing—
I stopped for years
my voice buried in sound-proofed
layers of life and now
when I, in theory, should
still be howling daily because of the
yous who've left me
behind, I keep it down to a few
unexpected sobs a month
And raise my voice
notch by notch until
it settles into song,
words not needed
just the lifting
the sailing of a few notes
out into the sky's scoring
—a bird for a breeze of a
moment, without the
winging, the necessary
travail of chase and
retreat

# Build Me a Bridge of Bones

Over to you, back to me

Gather the lightest ones, wings of gull
that have flown and floated
and weave their hollow cloud dreams
into a web of connection

Make the catwalk as high as an average sprung sky

Let the concepts of dovetail and suspension
bubble into a weft
a lattice of our in-betweens
bridge of sighs

Hire whooping cranes for the heavy lifting

Let birdbrains design the trestles
to brace a thread of bone between
over here and
over there

Between a distant wave and sudden embrace

In the middle of all of it, look down
into yesterday's impossible path
and walk now along a tightrope of possible
bare feet stirring wingbeat ghosts

As the bracing trestles begin to
speak the language of across, of just now
let the scribes redraw the maps
rewrite the local language of across and
plait the comings and goings into a stunning braid of
bone that sits high above a river

A chair without legs, a path without boat

Let the bones rattle-sing with each crossing
as you bring your breath of fresh apples
from ancient orchards to my hunger

As I bring you a peachfire of
ripeness in each hand to
your darkness

As our paths sashay through the
bonesong toward
a pinnacle of reach

# Angus

We thought we were clever—
the one with the idea
the one with the piece of wood and pen
the one with the hammer and nails
We wrote out the declaration
hammered it on the other side of
the swinging gate of barbed wire

NO CATTLE ALLOWED BEYOND THIS POINT Ø.
Some days, we'd go beyond the gate
into angus range and play beneath
the dry ponderosas that
smelled like pineapple, even though
we knew well enough the bulls didn't
suffer loud kids lightly
even when they were accompanied by
large fierce dogs

So we played with an eye out for
movement in the key of black—bull or bear—
in the soft dry green and
cinnamon world

*for Tonda Moon*

# The Twigs

Snapped off by
winter's icy muscle,
thrown down in
spring's stormy
assertions
I gather them
wonder if they might be
fragments of prayer,
unbroken
as the trees release
their fingered truths

# Ballet Arithmetic

A poem in itself
harp plus prima donna
but from the pit
more guts,
the sound of pluck
tap of toe shoe on
stage plank
torque of spin
the impeccable
geometry of arpeggio

And up on stage
the thump after leap
reminding us of
gravity defied
and the returning
respect for
Isaac Newton,
the rogue apple's
notorious fall,
informing

# A Trio of Crow

just flew into my
late-winter maple
and feast now upon
the samaras
with the delicacy
of mammoths
almost falling off
the bouncing branches

How are we matched
to what we really need?
Sometimes it is almost
a state of grace—the bear
and the blueberry,
the bee goosing the lupine,
a deliberate slicing of onion

and at other times, almost
a dance with quail bones
while handcuffed and shackled
graceless and
entirely necessary

# Contours

> Now I again need the contour,
> that it gather and capture.
> —Paul Klee

Give me a day
give me a night
where every line
is curved
and my only task
through those
long-limbed hours
is to

be

Australian-born Katrin Talbot's collection *The Waiting Room for the Imperfect Alibis* was recently released by Kelsay Books. *Wrong Number* is forthcoming from Finishing Line Press, and she has six other chapbooks, including *The Blind Lifeguard* and *Freeze-Dried Love* from Finishing Line Press, *Attached—Poetry of Suffix*, *The Little Red Poem*, and *noun'd, verb*, all from dancing girl press, and *St. Cecilia's Daze*, published by Parallel Press. Her poetry has appeared in many journals, including *Main Street Rag, Trouvaille Review, Fresh Ink, Bramble,* and *Your Daily Poem* and many anthologies. Talbot is also a violist and photographer, and her coffee table book, *Schubert's Winterreise-A Winter Journey in Poetry, Image, and Song* was published by the University of Wisconsin Press. She also has two Pushcart Prize nominations and quite a few chickens.

# Acknowledgments

"The Rabbi Gets Her Nails Done"
*Bramble*
"Pull Me Through Your Hallelujahs"
*Minnesota Public Radio*
"The Night I played a Beethoven Sonata Drunk"
*If Poetry Journal*
"The Shopping Cart Estates"
*Empty Shoes: Poems on the Hungry and the Homeless Popcorn Press*
"In the Key of Donut"
*The Book of Donuts,* Terrapin Books
"It's Not the Glacier's Imperative"
*Minnesota Public Radio*

# Title Index

**A**
- A Few Words .................... 69
- Allocation ....................... 30
- A Motorcycle Drove
  Right Through Prokofiev .......43
- Angus ............................78
- A Trio of Crow ..................81

**B**
- Ballet Arithmetic ................80
- Beneath .........................26
- Blessing in a White Dot ........17
- Build Me a Bridge of Bones ....76

**C**
- Contours ........................82
- Counting Bars ..................28

**D**
- Diva Lite .......................41
- Drive ...........................73

## F
Fanfare .................................................... 51
## G
Galileo After the Trial ............................... 42
## H
Here We Go Round .................................... 29
Horizon ...................................................... 44
Hot Stars .................................................... 21
## I
*I live among the crows* ............................... 54
*In* the dream after ..................................... 59
In the Key of Donut ................................... 65
*In* the language ......................................... 55
Invitation to the Polka ............................... 68
In Which a Chorus of Crow ...................... 61
In Which the Milwaukee Symphony
    Forgets to Pay the Violas ...................... 70
I Play My Scales to the Mourning Doves ............... 16
It Is with Great Honor .............................. 71
*It's* not the glacier's imperative ................. 66
## M
Madam Nanette ......................................... 24
Maestro ...................................................... 36
March Fourth ............................................. 64
Mrs. Morpurgo ........................................... 50
## N
Named ........................................................ 37
New Repertoire .......................................... 34
Night Snow ................................................ 72

**P**

Passported ..................................................... 23
Puddle ............................................................ 27
Pull me through your Hallelujahs .................. 31

**R**

Return from the Land of Injured .................. 52
Reverse .......................................................... 57

**S**

Shadow Sword .............................................. 19
Sir John A. McDonald .................................. 53
Supermarket Morality .................................. 67

**T**

The Barber of Seville Stirs My Coffee ........... 60
The City Was Heavy with
   Beethoven Last Night ............................... 39
The Devil Orders a Latte .............................. 38
The Night I Played a
   Beethoven Sonata Drunk ......................... 35
The Old Mathematician
   Dials His Cell Phone ............................... 22
The Piano Tuner's Beat ................................ 18
The Premiere of a Sixth Quartet .................. 48
The Rabbi Gets Her Nails Done .................. 20
The Shopping Cart Estates .......................... 58
The Twigs ..................................................... 79
Twenty Hearts .............................................. 56
Two Sixteenths, Two Eighths ...................... 40

**W**

Why I Keep ................................................... 75
World Without End ..................................... 45

89

# First Line Index

### A
A blessing for Australians .................... 50
About the primaries .................... 69
A drive to a morning lake swim .................... 19
After the final chords .................... 57
and a piece of crumb cake .................... 38
And I was to judge .................... 56
*And meet the enemy* .................... 64
A poem in itself .................... 80
as we streamed out from .................... 39
A week after opening night .................... 60

### B
Back then .................... 68
Because they're stuck .................... 16
blasts into the recital .................... 61

### G
Give me a day .................... 82

## H

Handed to me .................................................. 17
Have you ever tasted a donut in ..................... 65
He doesn't seem nervous ................................. 48
He passed me like a caffeinated ghost in ....... 42
He said ............................................................. 36

## I

*I live among the crows* .................................... 54
I locked the clever talking heads .................... 34
I'm guessing it was a night .............................. 45
*In* the dream after ........................................... 59
In the etching, she is a strong face ................. 24
*In* the language ............................................... 55
In town ............................................................. 37
I think of the rhyme as ................................... 29
It's a simple pattern ......................................... 40
It's not anything .............................................. 18
It's not that he can't ........................................ 22
*It's* not the glacier's imperative ...................... 66
It was her second egg of ................................. 51
I was always on my ......................................... 23

## J

just flew into my ............................................. 81

## L

Last night ........................................................ 72
Late afternoon highway .................................. 73

## O

*Oh Be A Fine Girl, Kiss Me* ............................. 21
Oversaw, from his letters ................................ 53
Over to you, back to me ................................. 76

**P**

past the ghostly .................................................. 31
Plays nicely ...................................................... 41

**S**

's flute sonata ................................................... 43
She sat in front of me ........................................ 20
She wanted us .................................................. 44
singing ............................................................. 75
Snapped off by ................................................. 79

**T**

that I sit here and watch .................................... 71
The cello .......................................................... 52
The entire section ............................................. 70
This afternoon ................................................. 26
This morning ................................................... 27

**W**

Well, so was the ............................................... 35
We really do not need to ................................... 28
We share a street, some unhoused and I ............ 30
We thought we were clever ................................ 78
We went to the park around .............................. 58

**Y**

You've hunted and gathered .............................. 67